...s.	Nature de la Commande.	Nombre de Clichés.	Nombre de Poses	Date de la promesse des types.	Date de la livraison des types.
...hs f² Fritonnière ...esherbes ² Maletherbes.	C. V. reprod. n° Clichés Divers	7	7	Jeudi 2 heures	24/12
...umarchais	alb. ✗	1	2	Mardi	28/12
	alb. ✗	1	2	D°	27/12
...mennais.			3	D°	29/12
...✗ C. Nadar	34/ ✗#0	1	1	D°	29/12
	V. V². ✗	1	1	D°	29/12
...ueur	alb. ✗	2	6.	Samedi	24/12

The World of Proust

as seen by Paul Nadar

The World of Proust

as seen by Paul Nadar

edited by
Anne-Marie Bernard

preface by
Pierre-Jean Rémy
of the Académie Française

photographs by
Paul Nadar

translated by
Susan Wise

The MIT Press
Cambridge, Massachusetts
London, England

Cover photograph: Marcel Proust, in 1887, at the age of sixteen
Flyleaf excerpts from the Christmas order form (pp. 36-37)

This work originally appeared in France under the title *Le Monde de Proust vu par Paul Nadar*.
© 1999 Centre des monuments nationaux/Monum, Éditions du Patrimoine, Paris

This book was set in Granjon and was photoengraved, printed and bound in Prodima/Bilbao, Spain.

Library of Congress Cataloging-in-Publication Data

Nadar, Paul, 1856-1939.
　　[Monde de Proust vu par Paul Nadar. English]
　　The World of Proust, as seen by Paul Nadar / edited by Anne-Marie Bernard; preface
　　by Pierre-Jean Rémy; photographs by Paul Nadar; translated by Susan Wise.
　　　　p. cm.
　　Includes bibliographical references and index.
　　ISBN 0-262-02532-9 (hc: alk. paper)
　　1. Proust, Marcel, 1871-1922—Friends and associates—Portraits—Exhibitions.
　　2. Portrait photography—France—Exhibitions. 3. Nadar, Paul, 1856-1939—Exhibitions.
　　I. Bernard, Anne-Marie. II. Title.
　　PQ2631.R63 Z789413 2002
　　843'.912—dc21
　　[B]　　　　　　　　　　　　　　　　　　　　　　　　　　　　　　　　　　2002022968

Pleasure in this respect is like photography.
What we take, in the presence of the beloved object,
is merely a negative film; we develop it later,
when we are at home, and have once again found
at our disposal that inner dark-room, the entrance to
which is barred to us as long as we are with other people.

Marcel Proust
Within a Budding Grove, Vol. II, p. 239
(Remembrance of Things Past, 1924, Part II)

PREFACE

BY PIERRE-JEAN RÉMY

We have been hearing it for ages: Proust's work is boundless. *Remembrance of Things Past* is at once the record of a highly sensitive, supremely conscious Ego, and the logbook of all the feelings, the passions, the arts, and a few specific social circles at the grand turn of the nineteenth and twentieth centuries. That is why today, in a world that is already so thoroughly charted, we are constantly discovering new territories.

We might think of Proust's oeuvre as a perpetual, ever-revived flow of images experienced over and over in all the tenses of the past and the present, and of the future, too, one that belongs to us, readers of today and tomorrow. The Narrator's story will become a part of our own set of references, whose perspective is and will be magnified every time we reread *Things Past*.

The characters this mighty tide sweeps along are figures whose features and personalities, like the Narrator's, endure the test of time. The "ball of masks" in *Time Regained* is merely the excruciating allegorical representation of that dread fact. We recall the profound dismay of one of our friends whenever he would run across – each time with greater revulsion – Mme. Verdurin

elevated to the rank of Princesse de Guermantes. Could it be true? Oriane now barely on the same social level of the "Mistress," to whom Charlus would say, with a smile that was above contempt, that in matters of "society" and protocol, she simply "could not know"... Even more than the true nature of Saint-Loup's love affairs or of Odette's relationship with Cottard (of which Jean-Yves Tadié gave us *in extremis* a partial key in the appendix to the last volume of the La Pléiade edition), maybe the hardest for us to bear is the metamorphosis of the too-rich parvenue into a Princess, the gossamer creature of our imagination.

Now, Oriane de Guermantes, Mme. Verdurin and Odette de Crécy, every one of the ladies and demimondaines of *Remembrance*, had a model somewhere in the social circles of which Proust was also the chronicler. Whether it be Laure de Chevigné or Lydie Aubernon, the Nadar collections bring them to life for us with a fearsome objectivity.

We dreamed of all those ladies when Proust told us about them, and here they are: we should take a good look at them, we ought to if we want to know "such stuff as dreams are made on." With their low necklines or corseted up to their chins, they all look very naked to us. And if Charles Haas, photographed in 1895, does not disappoint us compared to the rather fond portrait

Proust made of Swann, the Bénardaky mother and daughter, stiff in their period poses, Odette and Gilberte *regained*, appear surprisingly vulnerable.

In the rising tide of memory, the small photographs, fingered one by one like the beads of a secular rosary, are there to remind us that a glance is all that is needed to give birth to a character and to entire pages of books, just like an uneven paving-stone or the stiffness of a starched napkin sets off in the writer the true return of time.

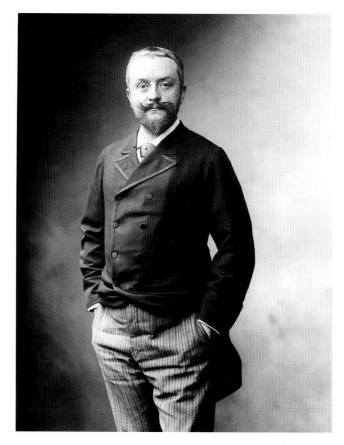

December 26th, 1888◆
Paul Nadar
(1856-1939)

Trained by his father, the great Félix Tournachon, known as Nadar, Paul Nadar took over the latter's studio on the rue d'Anjou in 1886. He is shown here at the time he photographed young Marcel Proust. Gaston Gallimard, in a letter of July 8th, 1922, informed the director of *Vanity Fair* that he was sending the New York magazine a photo of Proust taken by Nadar and kept in his files.[1]

◆ The date (in italics) quoted for each of the photographs of the book, barring a few exceptions, is that of the shot.

WHICH "WORLD OF PROUST"?

BY ANNE BORREL

See if you can find him! Just like in newspaper guessing games, there is someone hidden in this album. Moreover, he is in the margin, out of sight, off camera. Here he is, the sharp-eyed man with a baby face, pointed goatee and naughty moustache: the author, the creator, the deus ex machina. He is "Monsieur Loyal," the ringmaster who brings to life, for a hypothetical audience "in time," a parade of portraits everlastingly "out of time": clear-cut features, peach complexions, laces and fabrics whose colors and cuts we glimpse in the play of light and shadow. Captured in a flash on the emulsion sensitizing the glass plate, they all went to Paul Nadar's studio. And they all, we are told – except the one who brings them to life by freezing them there forever – appear, walk-ons or dancers, in *Remembrance of Things Past*, that colossal "ball of masks."

And yet these smiles, profiles, goatees, "bustles" – so typical of the turn of the century – do not pertain to ghosts or to characters of a novel photographed as they are about to enter the scene. They belong to real people: aristocrats, bourgeois, artists, demimondaines, actresses. The most prominent Parisian "beau monde" and "demi-monde" around the time during which the action of Marcel Proust's novel takes place – 1870-1920 – are assembled here. And since they have

something else in common, they can all pop out of the photographer's box at once: the author of *Remembrance* knew each one of them, frequented them, occasionally admired and even loved them. He collected, compared, collated, cherished, examined their photographs, stored them away in a drawer, year after year, and every once in a while would show them to his intimates; more often he would look at the portraits of the creatures he thus "possessed" by himself, poring over them time and again.

Ascribing this or that of their traits – physical or physiological – this or that of their attitudes or social behaviors, this or that of their "witty remarks" to the fictitious characters of the other "world of Proust," the one of his novel, of "real life" with which the writer equates "literature," is quite another story. Several persons "recognized" themselves, leading to estrangements. Proust had to deny a few too obvious "keys," which explains the famous dedication of *Swann's Way* to Jacques de Lacretelle: "[…] there are no keys for the characters of this book; or else there are eight or ten for a single one […]." His genius could hardly be content with such simplifications. He acknowledged a couple of thoroughly innocent "models" (Marie Bénardaky, Louis de Turenne, Charles Haas…) so as to better disguise unimaginable riddles. When Albert Le Cuziat, the keeper of the specialized "establishment," was asked if he were the model of the disreputable Jupien, he candidly and sensibly replied: "Yes, but there are several of us!"

Indeed, there were "several." The author's sensitive memory – an absolute memory if there ever was one – constantly brought back to him, whether he was aware of it or not, a thousand echos of past perceptions with their original vividness: a glance, a word, a tone of voice, a sound, a fragrance, a taste, the feel of a fabric, the color of a dress, the line of an eyebrow. Progressing from sketch to finished portrait, until they came to life, Proust *composed* his characters: details converged, successive touches were added, borrowed but imagined as well; the character gradually arose from the pen of the writer, who gave it life, his life; it became *real*.

Proust's introductory claim in his dedication of *Swann's Way* to Jacques de Lacretelle was an a posteriori explanation (it is dated April 1918) of one of the characteristic ways in which he worked; actually it was not known until its addressee published it, in 1923, in the "Tribute to Marcel Proust" of the *Nouvelle Revue Française*. It is always quoted when introducing an analysis of the "keys" in *Remembrance of Things Past*. Yet we should complete it by presenting the compositional method Proust provided in *Time Regained*: "Moreover, since individualities (human or otherwise) would in this book be constructed out of numerous impressions which, derived from many girls, many churches, many sonatas, would serve to make a single sonata, a single church and a single girl, should I not be making my book as Françoise

made that *bœuf à la mode* so much savoured by M. de Norpois of which the jelly was enriched by many additional carefully selected bits of meat?" The "girls" and the others, photographed by Paul Nadar, remain eternally "as they were"... Those who live in Proust's book "achieve form and solidity" in the world of the reader who, after the author, creates them with the eyes of the soul.

NADAR AND THE PHOTOGRAPHIC PORTRAIT

BY ANNE-MARIE BERNARD AND AGNÈS BLONDEL

The invention of photography entirely revolutionized the art of the portrait. In 1822, Nicéphore Niepce made the first photograph on glass: a still life that had required an eight-hour pose. It was not until 1839-1840 that the first photographic portraits appeared. Louis Mandé Daguerre was able to reproduce on a metal plate an image, reversed as if in a mirror, in a single exemplar. The daguerreotype developed at an extraordinary pace, but its vogue did not last over ten years. Concurrently, the Englishman William Henry Fox Talbot was able to obtain a paper negative, which he called "calotype," from the Greek *kalos* ("beautiful"), from which he drew positive images. But the grain of the paper was visible and the outlines of the image blurry, whereas the daguerreotype, being more sensitive – you could "count the paving-stones on a street" – continued to prevail. Up until 1860, calotypists kept up their efforts to improve the technique. During that short period, masterpieces of photography on paper were produced: landscapes, monuments and portraits.

The advent of the wet-collodion process on glass, in 1851, would put an end to the quarrel between the advocates of the blurry image (the paper negative) and the upholders of the sharp one (the daguerreotype). Wet collodion allowed photographers to obtain a glass negative, without grain,

thereby challenging the daguerreotype. The operation was delicate: the plate had to be sensitized just before taking the photograph and developed immediately, all in a quarter of an hour! Nonetheless, the process progressed by leaps and bounds. Photographic studios sprang up everywhere.

In 1854, the photographer Disdéri patented a photographic "carte de visite," the size of a calling-card. He made eight negatives on a single plate, thus considerably reducing the cost of the portrait. This invention was a tremendous success and was copied all over the world.

At the same time, Félix Tournachon, known as Nadar, received prominent figures from the worlds of art, literature and science. Allowing his model to move about freely, he did not take his photograph until he caught the characteristic expression. Étienne Carjat, whose portrait of Baudelaire is famous, worked in the same simple fashion. Other photographers preferred more elaborate poses, using accessories and imposing settings, like Disdéri, or trompe-l'œil backgrounds and draperies, like Adolphe Dallemagne (whose collection was taken over by Nadar).

The exceptional portraits of artists and writers by Félix Nadar were taken between 1854 and 1870. If by 1860 he had already begun to develop his clientele, it was especially in the early 1870s that he began taking photographs of "le Tout-Paris" and the world of the stage. At that time, he began training his son Paul, gradually giving him a greater role in the studio, until he handed it over to him entirely in 1886.

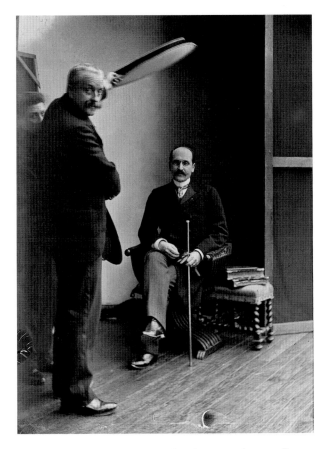

1894, Paul Nadar taking the portrait of M. de Giers, embassy attaché in Rome.

Photographic techniques continued to improve: in 1861 the dry collodion process was developed, allowing the plates to be prepared in advance. Then in 1880, silver-bromide emulsions were produced, so the plates could be commercialized and developed in a laboratory.

Finally, in 1888, George Eastman launched the Kodak, a handy device containing sensitive film. Photography was now accessible to everyone, and professional studios struggled to survive: they had to produce more, at lower prices, and cater to the public's taste. This led to a certain decline in the art of the portrait.

In 1891, there were more than a thousand photography studios in France, and Paris was certainly no less well equipped than the provinces. So it is unavoidable that in focusing on Nadar alone, we have to apologize for those who are missing in this *World of Proust*. The omissions we most regret are Marie Nordlinger, the friend with whom Proust worked on the Ruskin translations; Marie Finaly, his flirtation of the summer of 1892 and the sister of Horace Finaly, Marcel's schoolmate at the Lycée Condorcet; Céleste Albaret, who was in his service during the last eight years of his life; friends of his youth like Jacques Bizet, Daniel Halévy and Fernand Gregh, and the later ones, Anna de Noailles, Jacques-Émile Blanche, Lucien Daudet, Robert de Billy, Gaston Arman de Caillavet, the Bibesco Princes and Bertrand de Salignac-Fénelon.

In 1950, the State purchased from Paul Nadar's widow the entire photographic collection of the studio containing the works by Félix and Paul. That is how some 400,000 glass negatives became the property of the Ministry of Education, which commissioned the photographic archives department to conserve them. Just over one-fifth of the documents have been cataloged and are available, so the collection holds many other treasures in store for us. A considerable number of original prints, manuscripts and letters are conserved at the Bibliothèque Nationale de France. The case of this collection of photographic portraits is nearly unique: owing to the existence of the photographs, a large number of original prints, and order-books, we can appraise practically the Nadars' entire production.

The photographs reproduced here are printed from the full plate, so when they are half-length portraits (Anna de Castellane, Louise de Brantes, Geneviève Mallarmé), we can see the white disk the assistant held at a certain distance from the face; by reflecting the natural light, it improved the lighting. We felt it was worthwhile presenting two portraits of Mme. Proust taken the same day, one not retouched, and therefore more moving, next to the other, more familiar one, which had been retouched. We can also get a better grasp of the decor set up by the photographer, who availed himself of a vast range of scenes: large backdrops, rugs, pieces of furniture and various items. For Paul Nadar, especially for full-

length portraits, the setting was an essential factor, conferring on the photograph the desired mood. If, for the more austere portraits, he preferred a plain backdrop (Barrère, Pozzi, Brissaud) to the ones in a more romanesque vein, he sought a pictorial effect: a plant background (Élaine Greffulhe, Princesse Soutzo) or a large lake with its astonishing rock upon which Princesse Bibesco is half reclining. In the admirable portrait of Fauré, its poetry is entirely created by the misty background. It is also worthwhile mentioning the great care Paul Nadar took with the decor when he photographed Sarah Bernhardt, Julia Bartet and Réjane in their roles.

The close-ups, rather rare, are remarkably modern (Louisa de Mornand as early as 1905, Lucie Delarue-Mardrus in 1914, Léon Daudet and Cocteau in 1930, Coco de Madrazo in 1932). Very frequently, Paul Nadar's negatives (glass plates with silver-bromide gelatine) were retouched, mainly in the face; this explains the rather odd grain of Anatole France's skin, for instance. For the same person, there was often a choice to be made between several photographs, the model having been shot in different poses and at different dates. Furthermore, the technique of enlargement was not yet common practice, and Nadar had to make several trials in different sizes that coincided with the various prints requested.

The purpose of this book is not to offer a representation of the fictional characters of *Remembrance of Things Past* – where the connection with several real persons has only been

hinted at, unless Proust himself had admitted it or it were obvious. The problem of keys to their identity is tricky, and ultimately not essential for the reader of *Remembrance*. Instead, this is more like setting off on a sentimental journey, through Proust's life, in the company of those he knew and loved – rather like those times when he would take out of his commode drawer his beloved photographs to show them to Céleste.

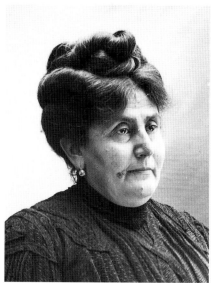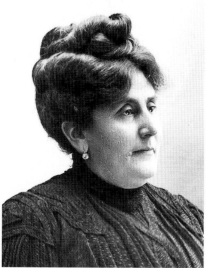

Mme. Proust, *December 5th, 1904*. The comparison between the natural portrait (left) and the retouched one (right) shows that the flaws and shadows that harden and age her face have disappeared.

THE PRINCIPLE OF RETOUCHING

BY ANNE-MARIE BERNARD

The remarkable portraits Félix Nadar had made of his friends, as well as of writers, artists and politicians, soon brought him considerable fame. He brought out what he really sought in each of them: the model's uniqueness and psychological depth. At that time, retouching the negative plate was performed only for technical reasons: to erase a small accidental stain, a gap in the emulsion, a scratch. But this way of working for art and for friends is not very profitable, anyway not enough to support a studio. A large number of photographers decided to set up their own businesses, especially in Paris, and, to be competitive, gave in to the biddings of a more sophisticated clientele: "Photographers had to conform their craft to the taste of a new public, the rich bourgeoisie."[2] Retouching, therefore, would become more widely adopted.

When Paul Nadar took over the studio in 1886, the retouching of negatives had already been practiced for some time, and for reasons of an aesthetic nature: the clientele sought a likable image of itself, glossy, attractive.

This is the type of picture we find in *Remembrance*: "[…] the grandmother […] had wanted, before it was too late, to leave behind the most flattering memory possible of herself."[3]

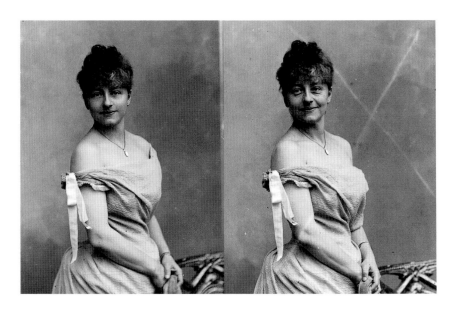

Gyp, in *1891*. Of these two poses taken on a same plate in the space of seconds, the one on the left, selected for the order, is retouched – no wrinkles, no circles or hard shadows; the one on the right, without retouching, was rejected, as we see by the X marked on the back of the plate.

In 1855 a controversy arose between Paul Périer (1812-c.1874), an art connoisseur, vice-president of the Société française de Photographie and a champion of retouching, and Eugène Durieu (1800-1874), president of the same Société, who was set on not amalgamating artistic practices. "So just let me retouch my negatives [...], if I improve them and upgrade them. [...] In short, let us use accurate retouching to achieve something better and more accomplished," Paul Périer insisted.[4]

The Munich photographer Franz Hampfstängl had been the one to invent the process of retouching the negative. At the 1855 World Exhibition in Paris he displayed for the first time a portrait with, and then without, retouching, producing a sensation.[5]

We can easily establish a comparison by placing side by side the portraits of Mme. Proust or of Gyp. Of the two poses, the one that was kept to be printed and given to the client had undergone, more or less depending on the desired result, the usual negative plate treatment: on the glass side, a mat coating that mellows the entire print when it is pulled, and allows one to accentuate the values and enhance them by stressing details; on the emulsion side, corrections carried out very delicately with a retouching pencil to erase flaws.

Retouching removes from the image details deemed unattractive: wrinkles, unsightly circles under the eyes, freckles, or bulkiness of the silhouette, as we can see by the

reduced waistlines for elegant Mme. Greffulhe or imposing Mme. Bénardaky… Gisèle Freund deplores the fact that the "thoughtless, excessive" use of retouching, by suppressing "all the characteristic qualities of a faithful reproduction, [...] deprives photography of its essential value."[6] This comment by the Narrator in *Remembrance* : "[...] the "touched-up" photographs which Odette had had taken at Otto's [...] did not appeal to Swann so much as a little "cabinet picture" taken at Nice [...],"[7] proves that the way we perceive an image depends on our sensibility.

In this book, all the portraits are modern prints faithful to the original plate, just as it came down to us from the Nadar studio.

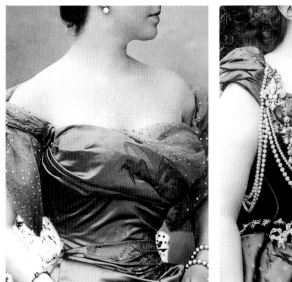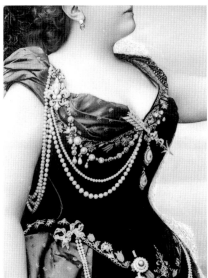

Comtesse Élisabeth Greffulhe, *May 30th, 1895*, and Mme. Nicolas Bénardaky, *June 30th, 1891*.
The coarsely retouched plates show in positive the white marks of the retouching pencil used to slim the waistline.

FAMILY AND INTIMATES

The child who played in the Champs-Élysées and later the youth vacationing on the Normandy beaches claimed his greatest misfortune would be "to be separated from Mamma." Indeed Proust and his mother were very close. To keep her son near her, she accepted his fitfulness, his whims, and later on his night-owl life. Proust was not as utterly taken up with his father, a dominant personality and a leading medical expert, who for a long time was dismayed by his elder son's peculiar behavior, before finally looking upon it with indulgence.

The difference between the Proust parents was apparent in their marked personalities and their social backgrounds. Adrien Proust was a modest provincial who, by dint of hard work, had won a scholarship. Jeanne Weil came from a Jewish bourgeois family, cultured and open-minded, whose income allowed for a certain level of luxury. Proust was raised astride those two worlds, in an intelligent, dedicated family.

Extremely sensitive and high-strung, Proust felt the affection of his family and of his friends as essential to his everyday life. So his intimates appear in this chapter as extensions of the close family circle.

December 5th, 1904

This picture of Mme. Proust shows her actual appearance down to
the slightest detail. Notice in particular her hands, which are swollen
by edema, a symptom of uremia; the framing of the print usually
eliminates them.

In this document you can see the two white cloth reflectors used to diffuse
the light on the subject.

Mme. Adrien Proust
née Jeanne Weil
(1849-1905)

The person whom young
Marcel most feared to be
parted from was a woman
of feeling. Completely
devoted to her husband
and her children,
animated and witty,
she was intelligent
and cultured.
She passed on to her
son the love of music
and helped him translate
Ruskin. She was also brave,
always concealing her
sorrows and afflictions.

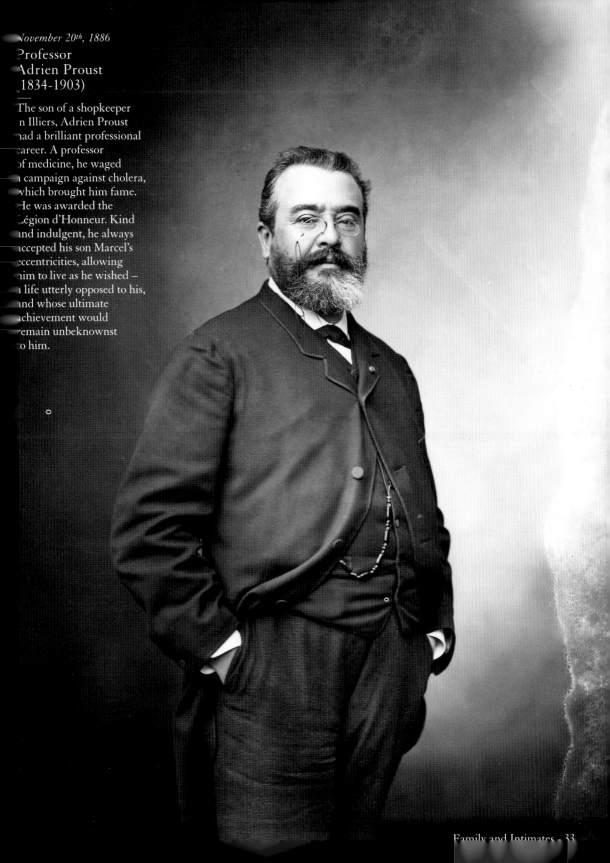

November 20th, 1886

Professor
Adrien Proust
(1834-1903)

The son of a shopkeeper
in Illiers, Adrien Proust
had a brilliant professional
career. A professor
of medicine, he waged
a campaign against cholera,
which brought him fame.
He was awarded the
Légion d'Honneur. Kind
and indulgent, he always
accepted his son Marcel's
eccentricities, allowing
him to live as he wished —
a life utterly opposed to his,
and whose ultimate
achievement would
remain unbeknownst
to him.

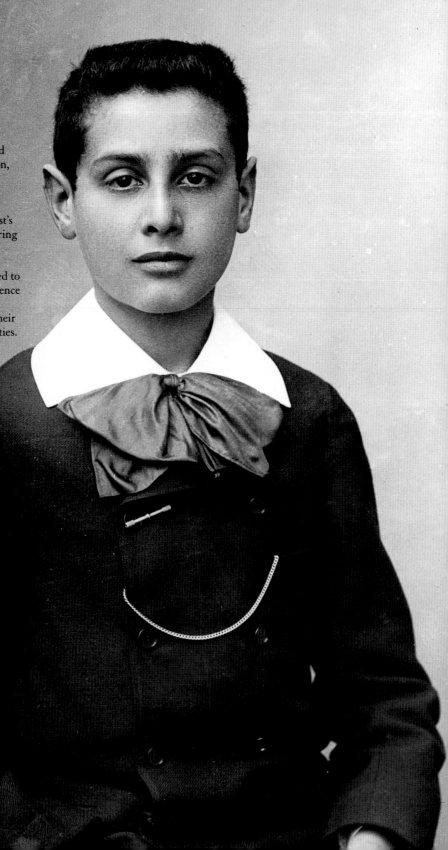

March 24th, 1887

Robert Proust
(1873-1935)

Robert Proust, two years
younger than Marcel, was
a fond, unselfish brother.
Despite his passion for
mathematics, he complied
with his father's wishes and
became an eminent surgeon,
professor at the Faculty of
Medicine and chevalier
de la Légion d'Honneur.
He inherited Adrien Proust's
professional drive, and during
the war was a model of
fearlessness and bravery.
This photograph, compared to
Marcel's, reveals the difference
in the two brothers'
morphologies, matching their
entirely opposed personalities.
Robert Proust was as fond
of sports as his older
brother was of
the theater
and salons.

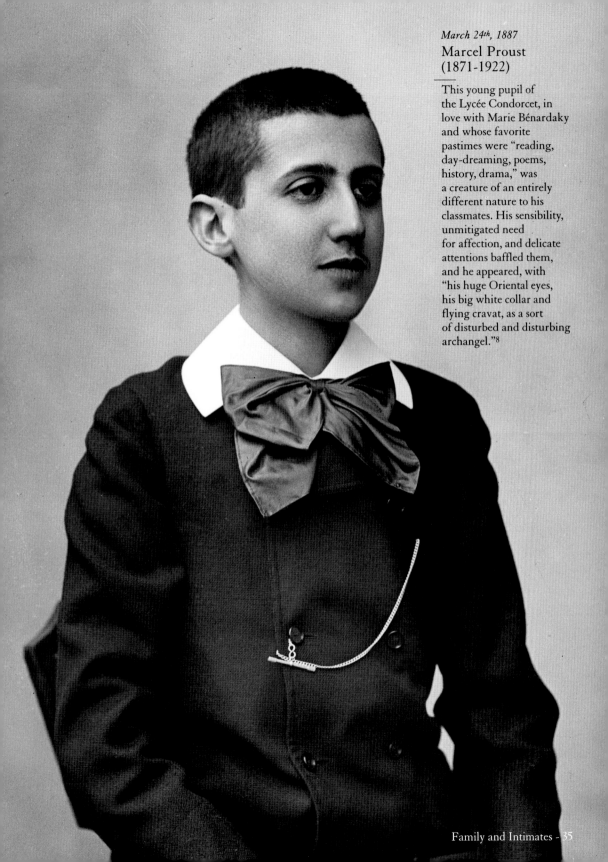

Marcel Proust
(1871-1922)

This young pupil of
the Lycée Condorcet, in
love with Marie Bénardaky
and whose favorite
pastimes were "reading,
day-dreaming, poems,
history, drama," was
a creature of an entirely
different nature to his
classmates. His sensibility,
unmitigated need
for affection, and delicate
attentions baffled them,
and he appeared, with
"his huge Oriental eyes,
his big white collar and
flying cravat, as a sort
of disturbed and disturbing
archangel."[8]

December 21st, 1892

The Christmas commission

On December 21st, 1892, Georges Weil, Mme. Adrien Proust's
brother, commissioned the Nadar studio to execute several
portraits of his parents, the Proust family, himself, his wife and
their baby. The description of the order, consisting of "four sets
of nine portraits and three copper easels under glass," specified
that they were to be delivered to the following addresses:
M. Nathée Weil, 40 bis, faubourg Poissonnière, Mme. Adrien
Proust, 9, boulevard Malesherbes, and Mme. Georges Weil,
24, place Malesherbes. Several of the portraits come directly from
the negatives conserved in the studio; for the others, we had to
reproduce prints from other firms, among which the Braun and
Van Bosch studios. You can see the mark of the thumbtack used
to hold them for the shot at the top of the prints.
This commission gives us the opportunity to observe the face
which Proust had begun to see as that of the Narrator's*
grandmother*: "A few days later I was able to look with pleasure
at the photograph that Saint-Loup had taken of her; [...] And yet,
her cheeks having unconsciously assumed an expression of
their own, livid, haggard, like the expression of an animal that
feels that it has been marked down for slaughter, my grandmother
had an air of being under sentence of death, an air involuntarily
sombre, unconsciously tragic, which passed unperceived by me
but prevented Mamma from ever looking at that photograph,
that photograph which seemed to be a photograph not so much of
her mother as of her mother's disease, of an insult that the disease
was offering to the brutally buffeted face of my grandmother."[9]

* The names followed by an asterisk are those of characters in *Remembrance
 of Things Past*. The asterisk appears only the first time the name is mentioned.

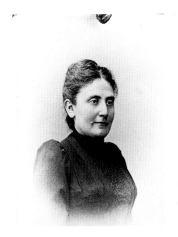

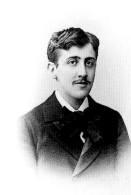

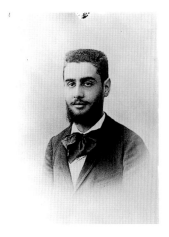

Jeanne Proust-Weil

Marcel at twenty

Robert at eighteen

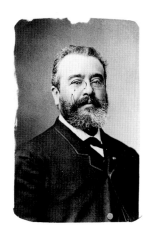

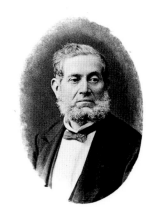

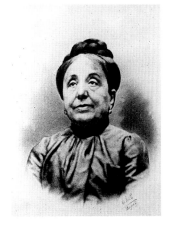

Adrien Proust

Nathée Weil,
the grandfather (1814-1896)

Adèle Berncastel-Weil,
the grandmother (1824-1890)

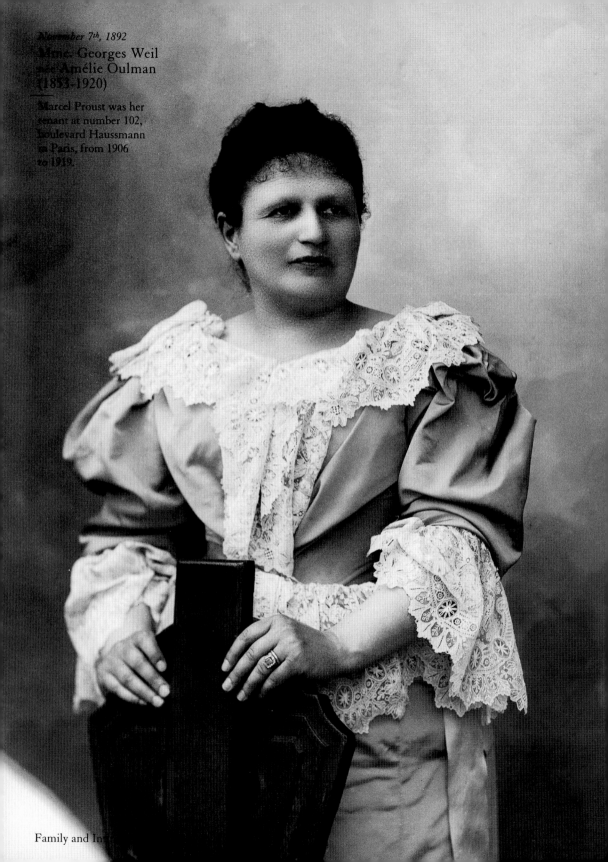

Family and Int

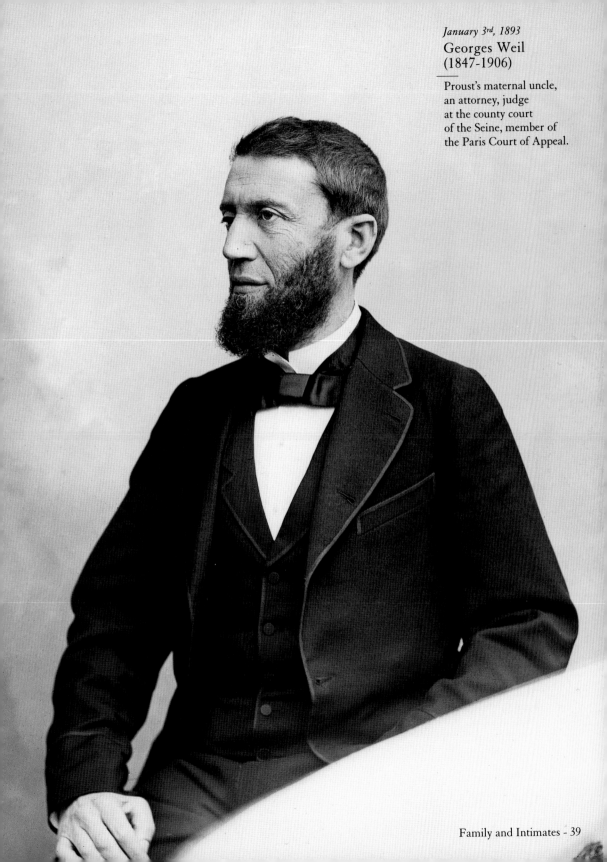

January 3rd, 1893

Georges Weil
(1847-1906)

Proust's maternal uncle,
an attorney, judge
at the county court
of the Seine, member of
the Paris Court of Appeal.

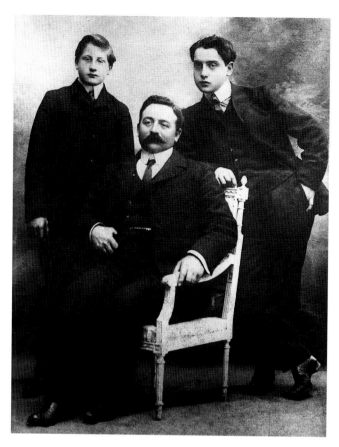

August 8th, 1914

Alfred Agostinelli (1888-1914) with his father and his brother Émile

Mechanic-chauffeur of the Unic taxi company run by
Jacques Bizet, Alfred Agostinelli (here on the right) drove Proust
through Normandy during the summer of 1907. These excursions
inspired "Impressions of an Automobile Trip," which appeared
in *Le Figaro* on November 19th, 1907. A few years later,
the former chauffeur became Proust's highly intimate secretary.
Having discovered Alfred's passion for airplanes, Proust bought
him one. In December 1913, Agostinelli left Proust, enrolling in a
flying school under the pseudonym "Marcel Swann." On May 30th,
1914, his monoplane crashed and sank in the Mediterranean.
Proust's deep feeling for Agostinelli and the grief he experienced
inspired an important episode in *Albertine Gone*.

Nicolas Cottin
(† 1916)

Nicolas Cottin and his
wife, Céline, were hired
by Proust in 1907.
They did not have the
devotion and admiration
for their master that, in
later years, Céleste Albaret
was to have, but they
remained in his service
– which was not easy –
for seven years. Nicolas,
who occasionally wrote
under Proust's dictation,
would say to Céline:
"His rigmaroles are as big
a bloody bore as he is, but
mark my words, when he's
dead he'll be a success
all right."[10] Although he
had a weak chest, Cottin
was sent to the front, where
he died of pleurisy in 1916.

Professor
Georges Dieulafoy
(1839-1911)

"In the sable majesty
of his frock coat
the Professor entered
the room, melancholy
without affectation,
uttered not the least word
of condolence, which might
have been thought insincere,
nor was he guilty of
the slightest infringement
of the rules of tact. At the
foot of a deathbed it was
he and not the Duc
de Guermantes who was
the great gentleman."[11]
Dieulafoy*, thus described
in *Remembrance* when
he attended the Narrator's
dying grandmother,
was a real person.
He held the chair of
internal pathology
at the Faculty of
Medicine and,
in 1896, was
appointed
Professeur
de Clinique
at the Hôtel-
Dieu in Paris.

April 28ᵗʰ, 1898
Gabriel Hanotaux
(1853-1944)

Gabriel Hanotaux, a friend of Adrien Proust, was Foreign Minister from 1894 to 1898 and then special emissary to Rome in 1920. He also wrote a number of historical studies. Thanks to his recommendation, Marcel was appointed librarian at the Mazarine library in June 1895, and would be granted the long leaves of absence he would request later on. Proust borrowed his diplomatic language for the character of M. de Norpois*.

Januar 1898
Camille Barrère
(1851-1940)

A diplomat, Camille Barrère was a friend of Dr. Adrien Proust, whom he backed in his campaign against cholera when England's accord was required to impose the quarantine line at Suez.
He was French ambassador to Italy from 1897 to 1924.

Reynaldo Hahn
(1875-1947)

The deep friendship that bound Proust to Reynaldo Hahn for twenty-eight years began with a liaison in 1894 and was kept up through a close correspondence. This young, highly gifted musician, the creator of *Ciboulette*, sang his melodies at Madeleine Lemaire's. Sensitive and refined, he was a dazzling conversationalist. Proust visited Brittany with him in 1895, and immediately started writing his first novel, *Jean Santeuil*: "I want you to be present all the time but like a god in disguise, unrecognized by mortals," he wrote him in March 1896.[12]

In 1900 they traveled to Venice together, in the company of Marie Nordlinger, a young relative of the Hahn family who had come to Paris to study painting and sculpture. Proust kept him up on his work, and did a first reading of *Swann's Way* to an enthusiastic Reynaldo.

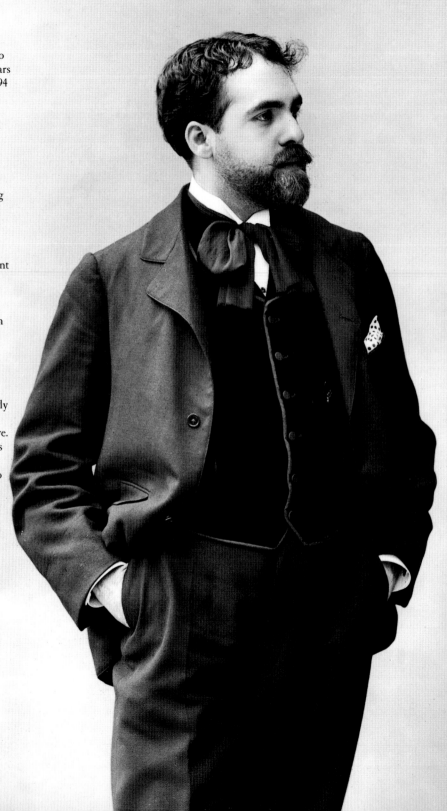

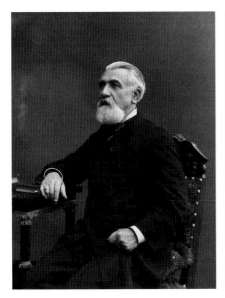

March 18th, 1881
Carlos or Karl Salomon Hahn
(† 1897)

December 1880
Mme. Carlos Hahn
née Elena Maria Echenagucia
(† 1912)

After making a fortune in Caracas, where he married a rich heiress of a Basque family settled in Venezuela, Carlos Hahn moved permanently to Paris in 1878. Proust was very close to the Hahn children, Reynaldo and his sisters, during the sickness and death of their parents. In July 1897, although suffering from an acute attack of asthma, he went out to the family's home in Saint-Cloud for news of Mr. Hahn. Then, fifteen years later, he observed the progression of Elena Maria's sickness with the same affectionate, grieving solicitude. "She was a woman with a generous heart and who had been a great beauty," he confided to Georges de Lauris in 1912.[13] That same year 1912, in an earlier letter dated January 3rd, he assured Mme. Hahn of his "veneration," his "tender, filial respect," thanking her for having shown him "a mother's kindness."[14]

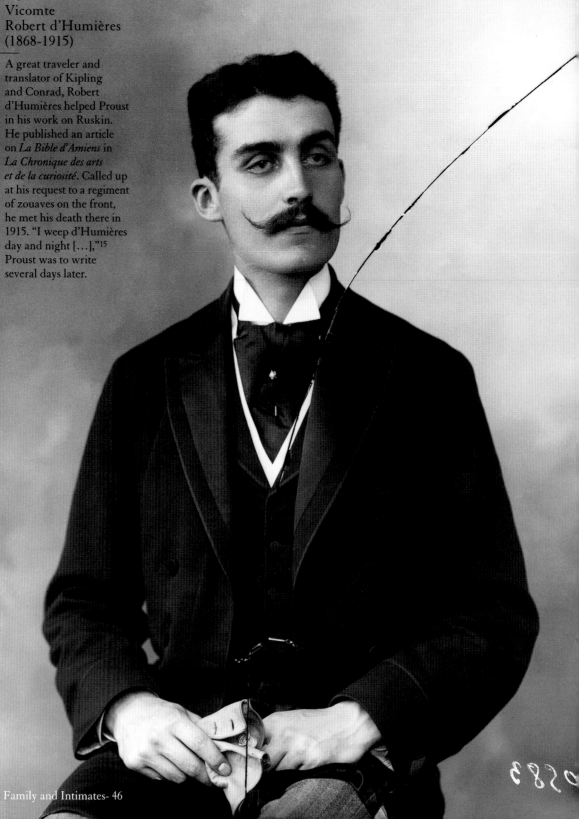

August 28th, 1892

Vicomte
Robert d'Humières
(1868-1915)

A great traveler and
translator of Kipling
and Conrad, Robert
d'Humières helped Proust
in his work on Ruskin.
He published an article
on *La Bible d'Amiens* in
*La Chronique des arts
et de la curiosité*. Called up
at his request to a regiment
of zouaves on the front,
he met his death there in
1915. "I weep d'Humières
day and night [...],"[15]
Proust was to write
several days later.

November 16th, 1900

Armand
Duc de Guiche
(1879-1962)

The Duc de Guiche met
Proust in 1903 at the poetess
Anna de Noailles' and was
immediately charmed by
his conversation. They met
often, with their friends
Louis d'Albuféra, Gabriel
de La Rochefoucauld,
Georges de Lauris and
Léon Radziwill, at the Café
Weber or the restaurant
Larue. Armand de Guiche,
a young aristocrat in
the style of Robert de Saint-
Loup*, was already a
brilliant physicist whose
research in aerodynamics
and optics made him famous
worldwide. He remained
close to Proust up until
the latter's death and did
him invaluable services.

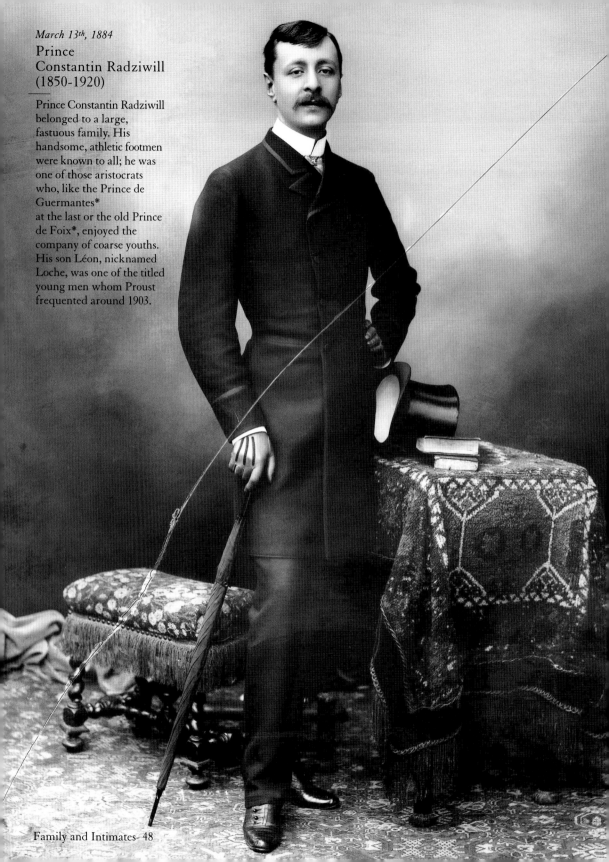

Prince Constantin Radziwill
belonged to a large,
fastuous family. His
handsome, athletic footmen
were known to all; he was
one of those aristocrats
who, like the Prince de
Guermantes*
at the last or the old Prince
de Foix*, enjoyed the
company of coarse youths.
His son Léon, nicknamed
Loche, was one of the titled
young men whom Proust
frequented around 1903.